CU00722229

CITY PANORAMAS
POCKET EDITION
360

BERLIN

NZ Visitor
Publications
Ltd,
Auckland
New Zealand

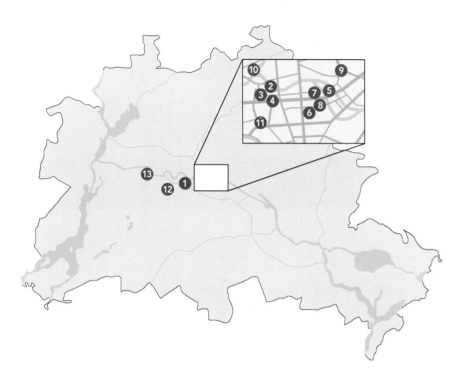

1. Tiergarten – *Blick von der Siegessäule – View from the Victory Column*

2. Berlin Mitte – *Reichstagsufer*

3. Berlin Mitte – *Reichstagskuppel*

4. Berlin Mitte – *Pariser Platz – Brandenburger Tor*

5. Berlin Mitte – *Museumsinsel*

6. Berlin Mitte – *Gendarmenmarkt*

7. Berlin Mitte – *Humboldt-Universität – Humboldt University*

8. Berlin Mitte – *Bebelplatz*

9. Berlin Mitte – *Hackesche Höfe*

10. Berlin Mitte – *Hauptbahnhof – Central Station*

11. Berlin Mitte – *Potsdamer Platz – Sony Center*

12. Charlottenburg – *Kurfürstendamm*

13. Charlottenburg – *Schloss Charlottenburg – Charlottenburg Palace*

Die Bundeshauptstadt Berlin ist mit 3,4 Millionen Einwohnern die größte Stadt Deutschlands und ein einflussreiches politisches Zentrum der Europäischen Union. Seit 1994 hat der Bundespräsident hier seinen Amtssitz und seit 1999 auch die Bundesregierung und der Bundesrat. Als bedeutender Verkehrsknotenpunkt wurde Berlin zu einem wichtigen Wirtschafts-, Kultur- und Bildungszentrum. Die Stadt verfügt über drei Flughäfen, der Binnenschifffahrt stehen drei Wasserstraßen zur Verfügung.

An den Universitäten, Kunsthochschulen und Fachhochschulen sind rund 140.000 Studenten eingeschrieben.

Die 1237 erstmals urkundlich erwähnte Stadt wurde bis 1918 von den Hohenzollern regiert. 1451 wurde Berlin Residenzstadt der brandenburgischen Markgrafen, 1701 Hauptstadt Preußens und 1871 Hauptstadt des Deutschen Reiches. Nach dem Ersten Weltkrieg wurde die Republik ausgerufen und nach der Machtergreifung der Nationalsozialisten 1933 wurde Berlin Hauptstadt des Dritten Reiches. Nach dem Zweiten Weltkrieg wurde die Stadt in vier Sektoren aufgeteilt, 1949 die Bundesrepublik Deutschland (Westen) und die Deutsche Demokratische Republik (Osten) gegründet. Die Teilung gipfelte 1961 mit dem Bau der Berliner Mauer, die 1989 wieder fiel.

Die multikulturelle Stadt verfügt über viele Kirchen, Synagogen und Tempel. Bedeutende Medien haben hier ihren Sitz, zahlreiche Theater, drei Opernhäuser, mehrere Orchester und Chöre sind in Berlin ansässig. Die vielen Museen verfügen über exzellente Sammlungen und wertvolles Kulturgut. Das Brandenburger Tor ist Berlins Wahrzeichen. Zu den bedeutendsten historischen Gebäuden zählen die Deutsche Staatsoper, die Staatsbibliothek, das ehemalige Zeughaus, die Marienkirche, die Hedwigs-Kathedrale, der Französische Dom, die Humboldt-Universität, das Reichstagsgebäude und die Schlösser Charlottenburg, Tegel und Bellevue. Die bemerkenswertesten moderneren Gebäude sind der 368 m hohe Fernsehturm, das Olympiastadion und die Regierungsgebäude. Die 2.500 Grünanlagen mit über 5.500 ha Gesamtfläche bieten vielfältige Freizeit- und Erholungsmöglichkeiten.

The federal capital Berlin is Germany's biggest city with 3.4 million inhabitants, and an influential political center of the European Union. Since 1994, the German Federal President has his residence in Berlin, with the government and Bundesrat following in 1999. As an important national and international traffic hub, Berlin developed into a significant economic, cultural and educational center. The city has three airports, and there are three bodies of water for inland navigation. About 140,000 students are enrolled in the city's universities, art academies and universities of applied sciences.

After being first documented in 1237, the city was ruled by the House of Hohenzollern until 1918. In 1451, Berlin became the royal seat of the margraves of Brandenburg. Berlin was made the capital of Prussia in 1701, and the capital of the German empire in 1871. After World War I, the German Republic was proclaimed, and Berlin became the capital of the Third Reich, after the National Socialists seized power in 1933. In the aftermath of World War II, Berlin was divided into four sectors, and the year 1949 saw the foundation of the Federal Republic of Germany (west) and the German Democratic Republic (east). The separation found its climax in 1961 with the construction of the Berlin Wall, whose fall was in 1989.

The multicultural city has many churches, synagogues and temples. Important media enterprises are located in the city, as well as many theatres, three opera houses and several orchestras and choirs. The city's many museums possess excellent collections and valuable cultural artefacts. The Brandenburger Tor is Berlin's famous landmark. Among the most important historic buildings are the opera house of the "Deutsche Staatsoper", the National Library, the former arsenal, St. Mary's Church, St. Hedwig's Cathedral, the "Französischer Dom", Humboldt University, the Reichstag and the palaces Charlottenburg, Tegel and Bellevue. Modern buildings of note include the television tower with a height of 368 m, the Olympic stadium, the radio tower and the buildings of the federal government. Berlin's 2,500 parks covering a total area of 5,500 ha offer great opportunities for recreation.

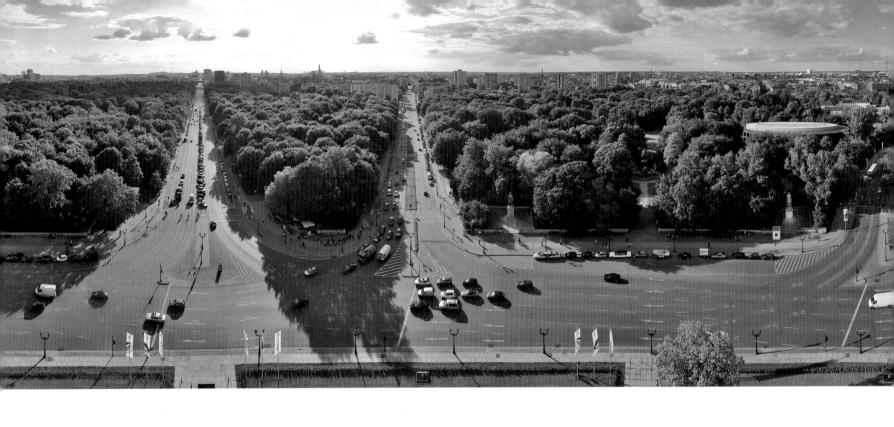

Blick von der Siegessäule – View from the Victory Column

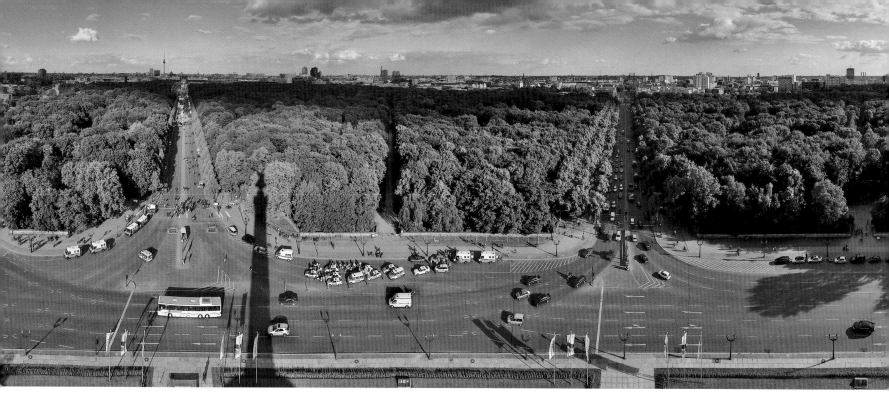

Von der Aussichtsplattform der Siegessäule am Großen Stern hat man aus 50 m Höhe einen grandiosen Überblick. Die Straße des 17. Juni (links) erinnert an den Tag des Volksaufstandes in der DDR 1953. Der Spreeweg (Mitte) führt vorbei am Schloss Bellevue an das Ufer der Spree und zum Kurfürstenplatz. Teile der Straße wurden zwischenzeitlich umbenannt. Die Hofjägeralle (rechts) wurde so benannt, weil an ihrem Ende das Haus des königlichen Hofjägers stand.

From the viewing platform of the Victory Column on "Großer Stern", you have a fantastic view at a height of 50 m. The name of the "Straße des 17. Juni" (left) commemorates with day of the sweeping national uprising in the GDR in 1953. Spreeweg (center) passes by Bellevue Palace, leading to the banks of the Spree and on to Kurfürstenplatz. Hofjägerallee (right) derives its name from the house of the royal gamekeeper standing at its end.

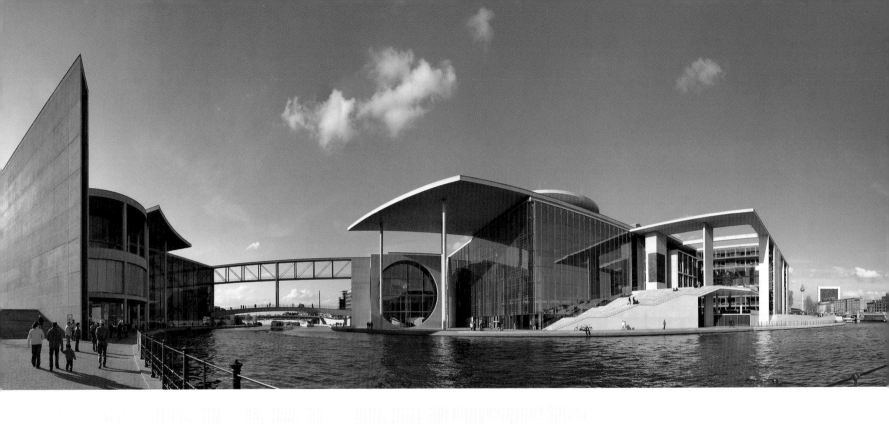

Reichtagsufer

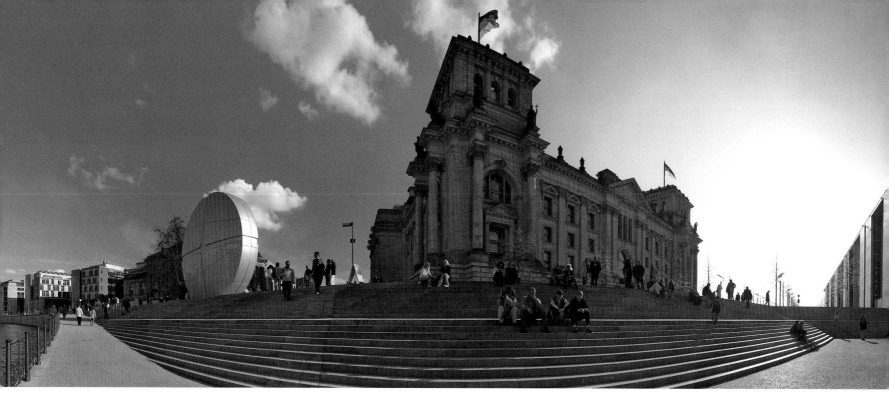

Nach Plänen von Axel Schultes und Charlotte Frank begannen 1997 die Bauarbeiten für die neuen Regierungsgebäude. Das Paul-Löbe-Haus (links) und das Marie-Elisabeth-Lüders-Haus sind durch den „Spreesprung" verbunden, der die Wiedervereinigung des hier einstmals getrennten Deutschlands symbolisiert. Das Reichstagsgebäude (rechts), wurde 1881-84 nach Plänen von Paul Wallot errichtet. An der Ostseite des Gebäudes verlief 1961-89 die Berliner Mauer.

In 1997, construction began on the new buildings for the federal government. The "Paul-Löbe-Haus" (left) and the "Marie-Elisabeth-Lüders-Haus" are connected by the "Spreespung", the "leap across the Spree", symbolizing the reunification of the country that was once divided here. The building of the "Reichstag" (right) was built in 1881-84, according to plans by Paul Wallot. Between 1961 and 1989, the Berlin Wall ran along the east side of the building.

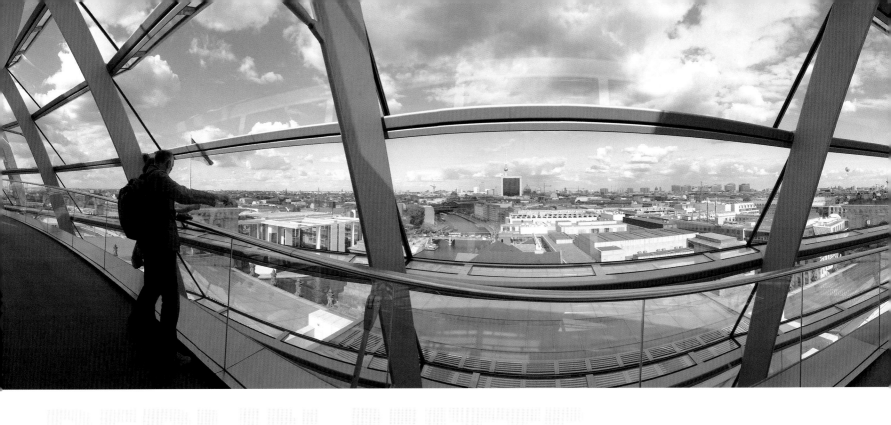

Reichstagskuppel

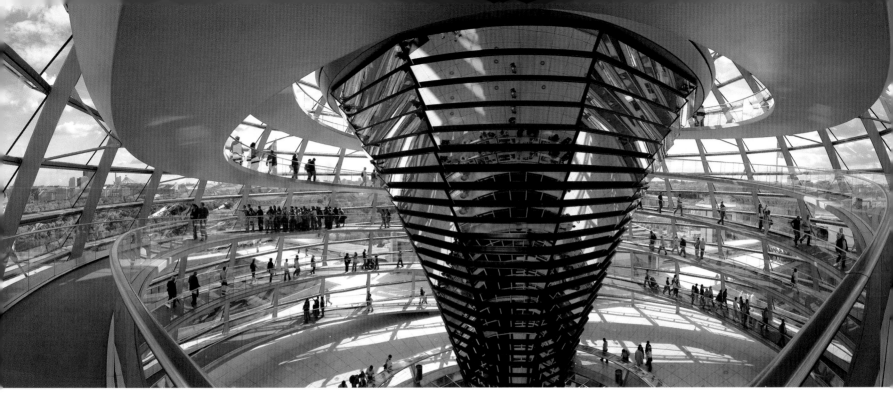

Die begehbare Kuppel des Reichstags wurde 1995-99 unter besonderer Rücksichtnahme auf ökologische Faktoren umgebaut und ist heute ein Wahrzeichen Berlins. Mit einer Glasfläche von 3.000m² dient sie der Belichtung und Belüftung des Plenarsaals, der den Mittelpunkt des Reichstagsgebäudes bildet. Die Kuppel ist mittlerweile von knapp 20 Millionen Menschen besucht worden und ist damit das öffentlichkeitswirksamste Gebäude der Welt.

The walkable dome of the "Reichstag" was built in 1995-99, with special consideration of ecological factors. Today, it is one of Berlin's landmarks. With a glass area of 3,000 m², it is used for lighting and ventilating the assembly hall at the center of the "Reichstag". So far, the dome has been visited by almost 20 million people, thus being the world's most public structure.

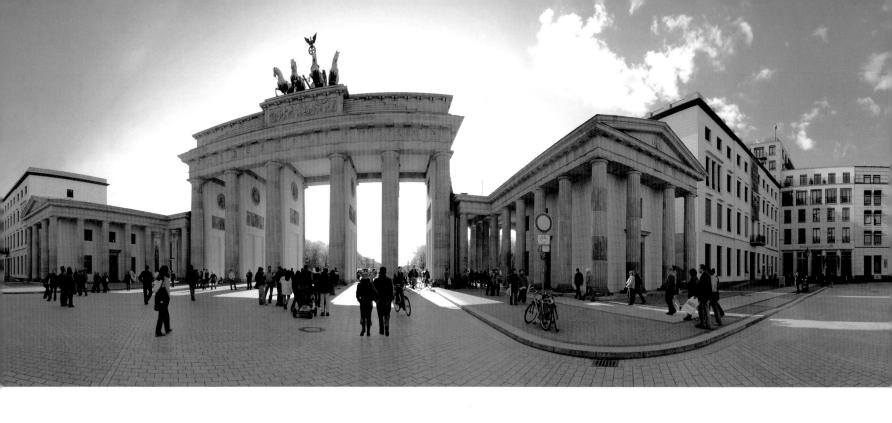

Pariser Platz – Brandenburger Tor

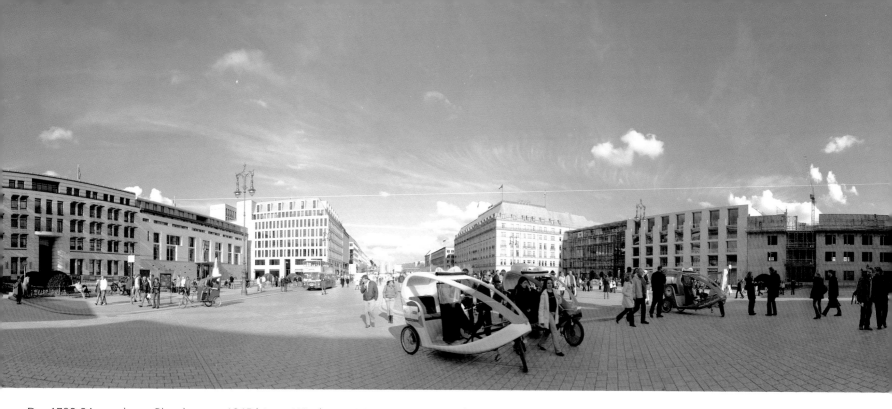

Der 1732-34 angelegte Platz lag von 1945 bis zur Wiedervereinigung zwischen Ost- und West-Berlin und war Teil des Todesstreifens. Das 26 m hohe und 65,5 m breite Brandenburger Tor (links) ist das bekannteste Wahrzeichen der Stadt, geprägt von sechs je 15 m hohen dorischen Säulen mit einem Durchmesser von 1,75 m. Gekrönt wird das Tor von einer etwa 5 m hohen in Kupfer getrieben Skulptur, die Siegesgöttin Viktoria mit ihrem Quadriga.

The square was designed in 1732-34. From 1945 until reunification, Pariser Platz lay right between East and West Berlin and was part of the death strip. The "Brandenburger Tor" (left) is 26 m high and 65.5 m wide. Berlin's most famous landmark is characterized by six Doric columns with a height of 15 m and a diameter of 1.75 m. The "Brandenburger Tor" is crowned by a 5 m copper sculpture depicting the winged goddess Victoria with her quadriga.

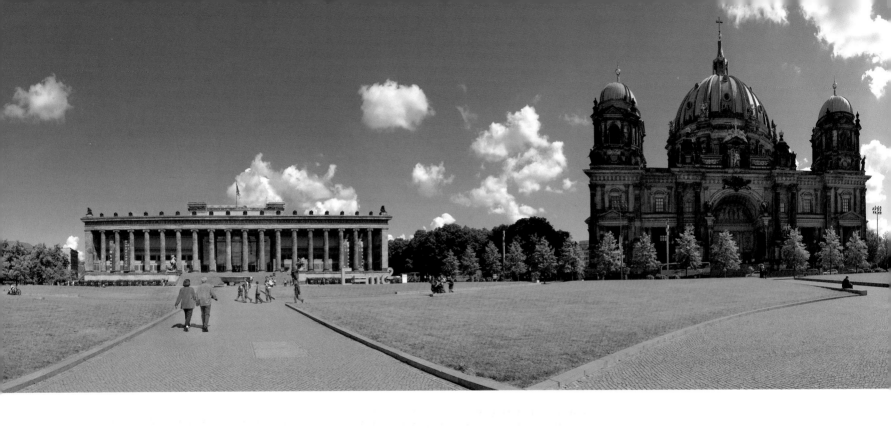

Museumsinsel

Auf dem ehemals sumpfigen Gebiet im nördlichen Teil der Spreeinsel entstand im 17. Jahrhundert eine Lustgartenanlage. 1830 errichtete man dort das Alte Museum (links), vier weitere Museen folgten. Die so entstandene Museumsinsel wurde 1999 in die Liste des Weltkulturerbes aufgenommen. Der 1894-1905 nach Plänen von Julius Carl und Otto Raschdorff errichtete Berliner Dom (Mitte) beherbergt die Hohenzollerngruft.

In the 17th century, the former swamp areas in the north of the "Spreeinsel" were turned into a park and leisure area. In 1830, the "Altes Museum" (left) was built there. Four other museums followed. The "Museumsinsel" was added to the World Heritage list in 1999. The "Berliner Dom" (center), built in 1894-1905 according to plans by Julius Carl and Otto Raschdorff, contains the crypt of the House of Hohenzollern.

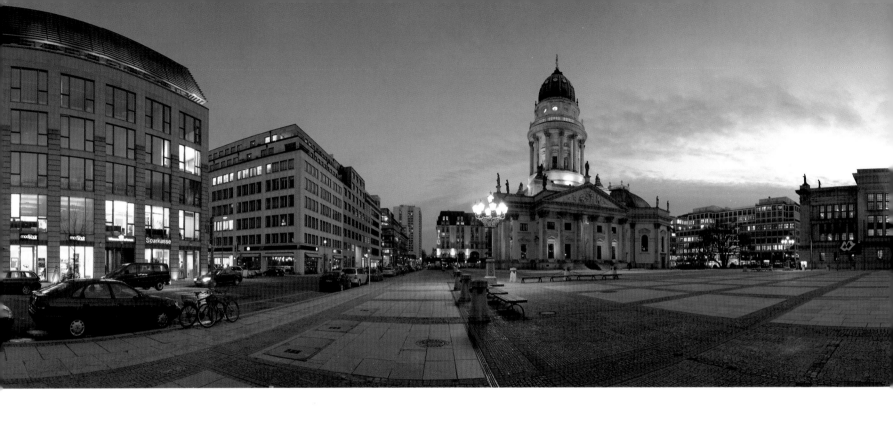

Gendarmenmarkt

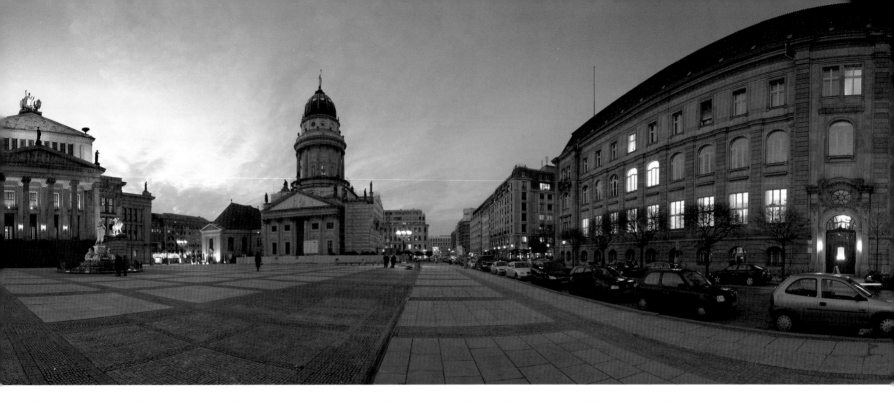

1688 angelegt, gilt der Gendarmenmarkt als der schönste Platz Berlins. Der Deutsche Dom (links) besteht aus der 1701-08 von Martin Grünberg errichteten Deutschen Kirche und einem Kuppelturm. Der Turm wurde im Zuge einer Neugestaltung des Platzes zugleich mit dem Französischen Dom (rechts) errichtet, 1881-82 wurde aber fast alles erneuert. Der rechteckige Bau des Konzerthauses (Mitte) entstand 1818-21 nach Plänen von Karl Friedrich Schinkel.

Designed in 1688, "Gendarmenmarkt" is said to be Berlin's most beautiful square. The "Deutscher Dom" (left) consists of the "Deutsche Kirche", built in 1701-08 and a tower with a cupola. The tower was built at the same time as the "Französischer Dom" (right) in the course of the square's renovation, but almost everything was renewed in 1881-82. The building of the concert hall (center) was constructed 1818-21 according to plans by Karl Friedrich Schinkel.

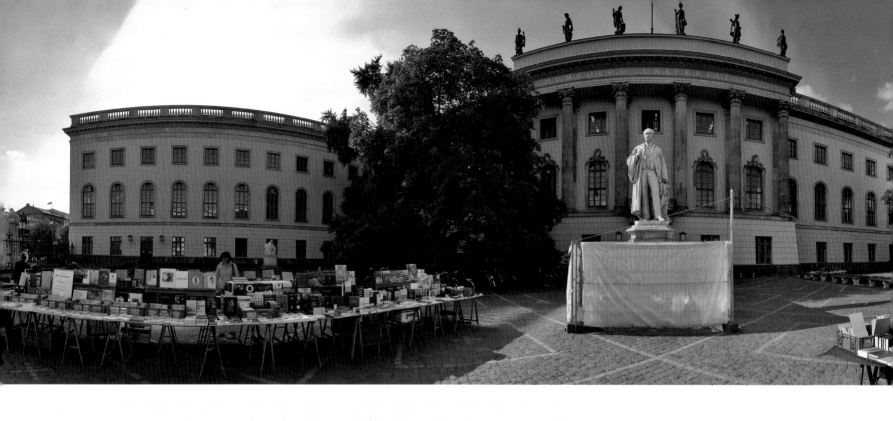

Humboldt-Universität – Humboldt University

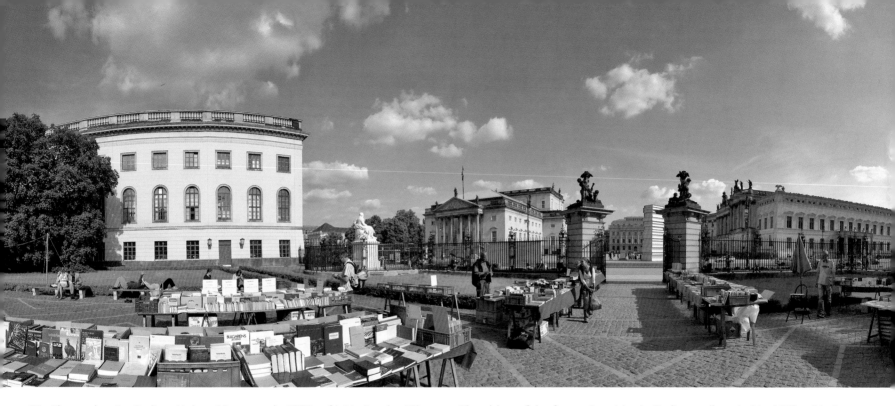

Die älteste der vier Berliner Universitäten wurde 1808 auf Initiative des Bildungsreformers, Diplomaten und Sprachwissenschaftlers Wilhelm von Humboldt gegründet und nahm 1810 mit 256 Studenten und 52 lehrenden den Lehrbetrieb auf. Von da an unterlag die „Alma Mater Berolinensis" stetigem Zulauf und Wachstum. Seit 1901 wurden nicht weniger als 29 ehemalige Studenten mit dem Nobelpreis ausgezeichnet.

The oldest of the four universities in Berlin was founded in 1808, with the initiative of educational reformer, diplomat and linguist Wilhelm von Humboldt. 52 professors began teaching 256 students in 1810. Since then, the "Alma Mater Berolinensis" has enjoyed ever more popularity and growth, supported by an expanding educational programme. Since 1901, no fewer than 29 former students became Nobel laureates.

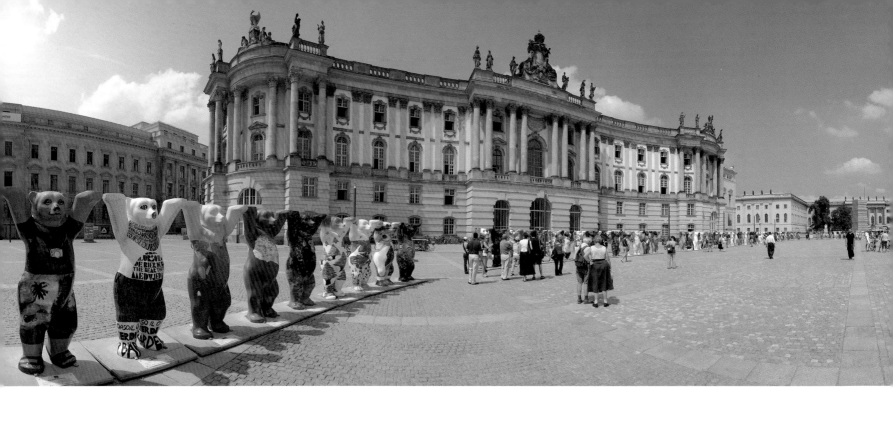

Bebelplatz

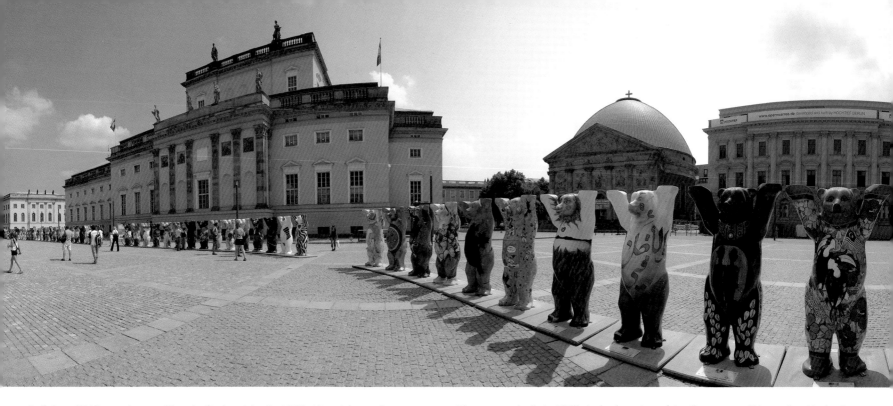

Auf dem 1740 angelegten Platz befindet sich die 1741-43 errichtete Staatsoper „Unter den Linden" (links). Daneben wurde 1747 nach Plänen von Friedrich dem Großen die St.-Hedwigs-Kathedrale errichtet. Das Mahnmal „versunkene Bibliothek" von Micha Ullmann erinnert an die Bücherverbrennung von 1933 vor der Humboldt-Universitätsbibliothek (rechts). Von den 142 Bären repräsentiert jeder ein Land der Vereinten Nationen.

The square, built in 1740, is the location of the Staatsoper "Unter den Linden" (left), built in 1741-43. Next to it, St. Hedwig's Cathedral was built in 1747 according to plans by Frederick the Great. The memorial "Sunken Library" by artist Micha Ullmann commemorates the book burning of 1933 in front of the library of Humboldt University (right). The 142 bears, each representing a country of the United Nations, has already been on a world tour.

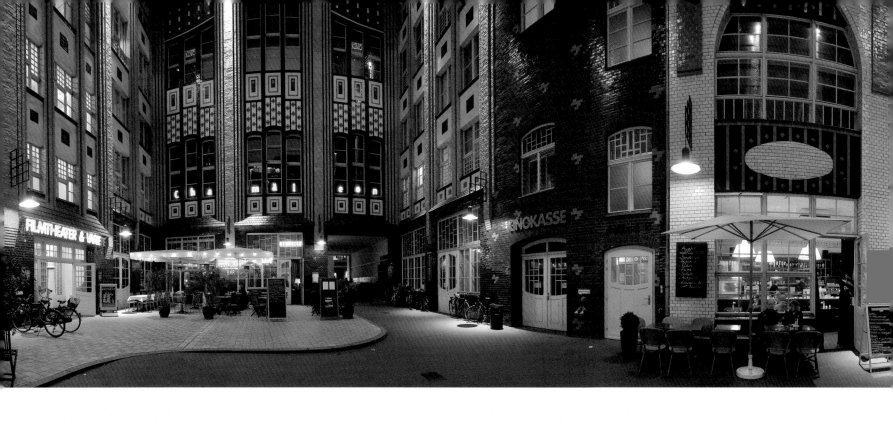

Hackesche Höfe

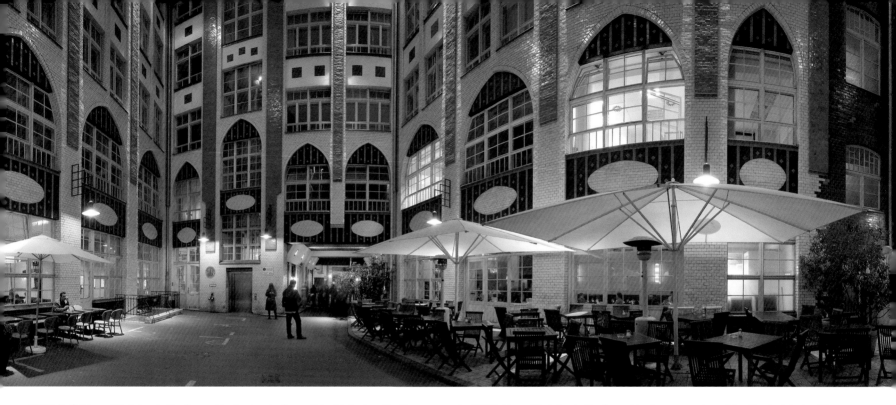

1750 ließ Hans Christoph Graf von Hacke im Auftrag Friedrich des Großen hier einen Marktplatz anlegen, auf dem 1906-07 die größte Wohn- und Gewerbefläche Deutschlands errichtet wurde. August Endell wurde mit der Gestaltung der Fassaden und Festsäle der aus acht Höfen bestehenden Anlage beauftragt. 1951 wurden die Höfe zum Volkseigentum der DDR erklärt, 1977 unter Denkmalschutz gestellt und von 1995-97 mustergültig saniert.

In 1750, Hans Christoph Graf von Hacke was ordered by Frederick the Great to create a market square. In 1906-07, Germany's largest residential and commercial area was built there. In 1951, the yards were declared public property of the GDR, with a listing as protected structures following in 1977. In 1993, the compound was returned to the former heirs, and the painstaking renovation was completed in 1997.

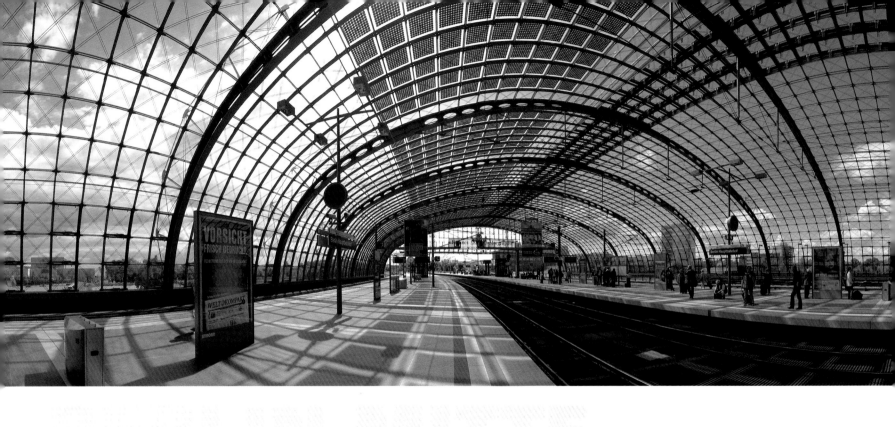

Hauptbahnhof – Central Station

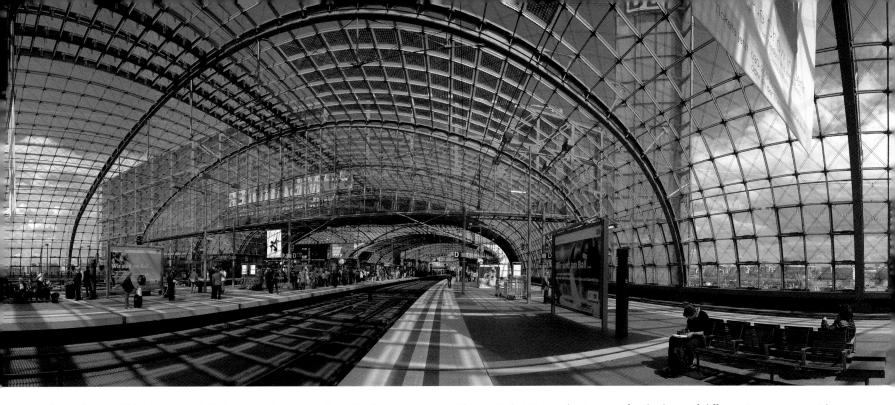

Der Hauptbahnhof bildet den Verknüpfungspunkt der an dieser Stelle zusammenlaufenden Linien verschiedener Verkehrsträger. Im Zuge eines „Pilzkonzeptes" wurde an Stelle des alten Lehrter Bahnhofs der Bau eines modernen Kreuzungsbahnhofes entworfen. Nach Plänen von Meinhard von Gerkan errichtete das Hamburger Architekturbüro Gerkan, Marg und Partner in drei Bauabschnitten zwischen 1995 und 2006 die neue Anlage.

The central station is the junction for the lines of different transport providers. Following a "mushroom concept", the old "Lehrter Bahnhof" was replaced by a modern train station. According to plans by Meinhard von Gerkan, the Hamburg-based architectural firm of Gerkan, Marg und Partner built the new station in three construction phases between 1995 and 2006.

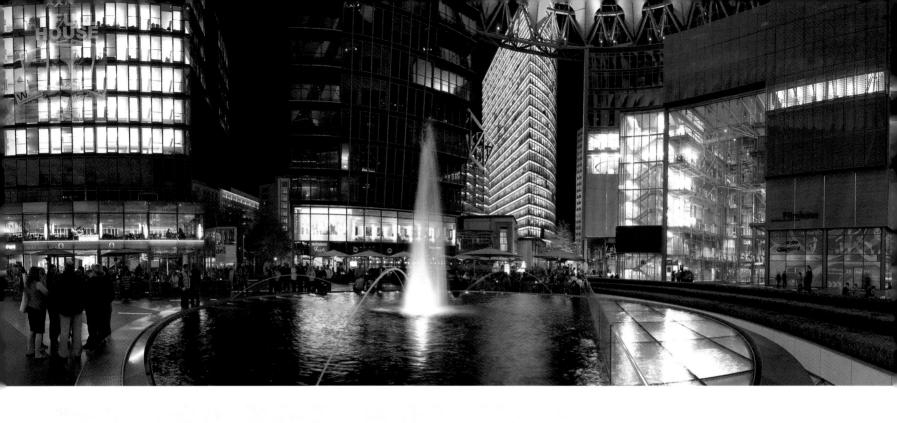

Potsdamer Platz – Sony Center

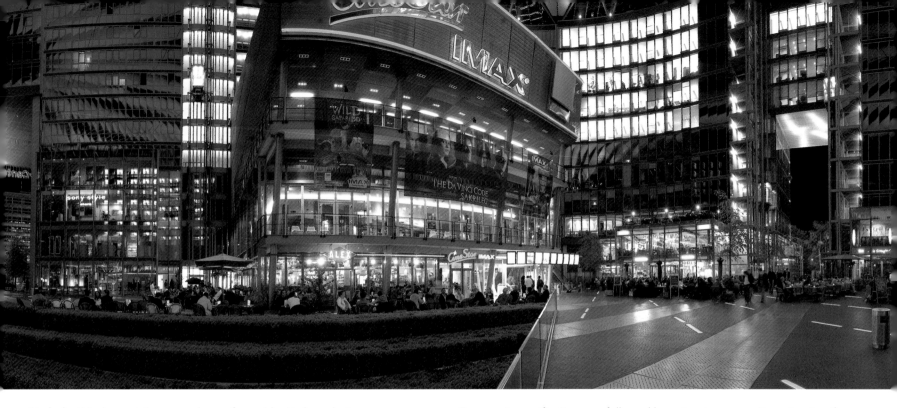

Nach der Wiedervereinigung wurden umfangreiche Umbauarbeiten vorgenommen, was den Potsdamer Platz zu einer Verkehrsdrehscheibe im Zentrum der Stadt werden ließ. Das 27.000 m² große Areal der Firma Sony (Bild) wurde von Helmut Jahn gestaltet und konnte im Jahr 2000 eröffnet werden. In der Nachbarschaft befinden sich der Bahn-Tower im Bild links, der Sitz der Holding der Deutschen Bahn und das Gelände des Automobilherstellers Daimler Chrysler.

Germany's reunification was followed by extensive renovations, turning the "Potsdamer Platz" into a traffic hub. The Sony Corporation possesses an area of 27,000 m² (photo), which is used for a variety of purposes. Helmut Jahn designed the complex, which was opened in 2000. The Bahn Tower in the immediate vicinity (left) is the headquarter of the "Deutsche Bahn AG Holding", with an adjacent area belonging to car producer Daimler Chrysler.

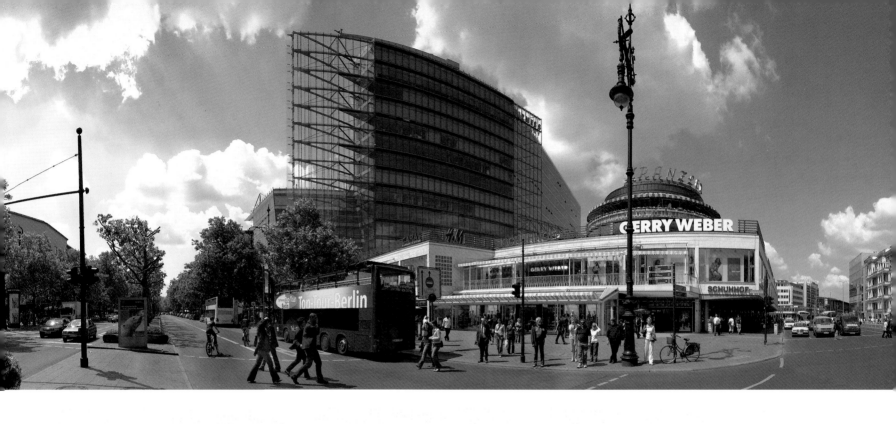

Kurfürstendamm

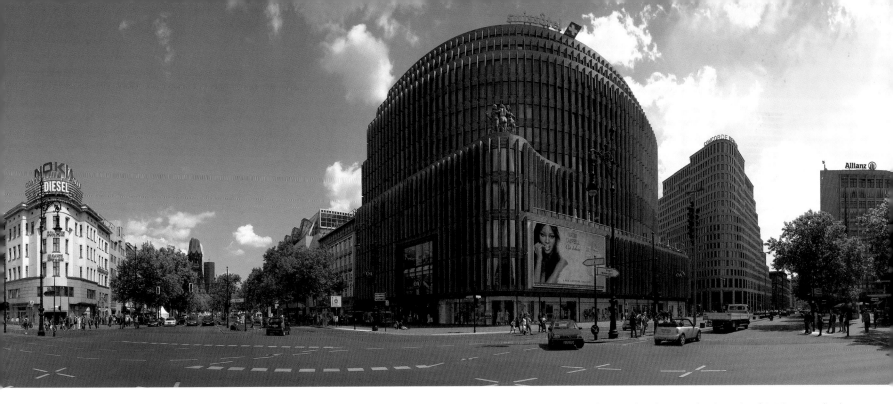

Der 3,5 km lange „Ku'damm" wurde 1542 als Verbindungsstraße vom Berliner Stadtschloss zum Jagdschloss Grunewald angelegt. 1875-86 wurde er auf Anregung Otto von Bismarcks in eine Prachtstraße umgebaut, die als Synonym der Goldenen Zwanziger Jahre galt. Nach dem Mauerfall verlor er zwar viel von seiner Bedeutung, ist aber immer noch eine der edelsten Straßen in Berlin, in der sich namhafte Läden und Hotelbetriebe angesiedelt haben.

The boulevard, called "Ku'damm" for short, with a length of 3.5 km was built in 1542 as a connection between the "Berliner Stadtschloss" and "Jagdschloss Grunewald". In 1875-86, it was turned into a boulevard on the initiative of Otto von Bismarck. During the Weimar Republic, the Kurfürstendamm was a symbol of the Golden Twenties. After the fall of the Berlin Wall, the boulevard lost its significance, but it is still one of Berlin's finest thoroughfares.

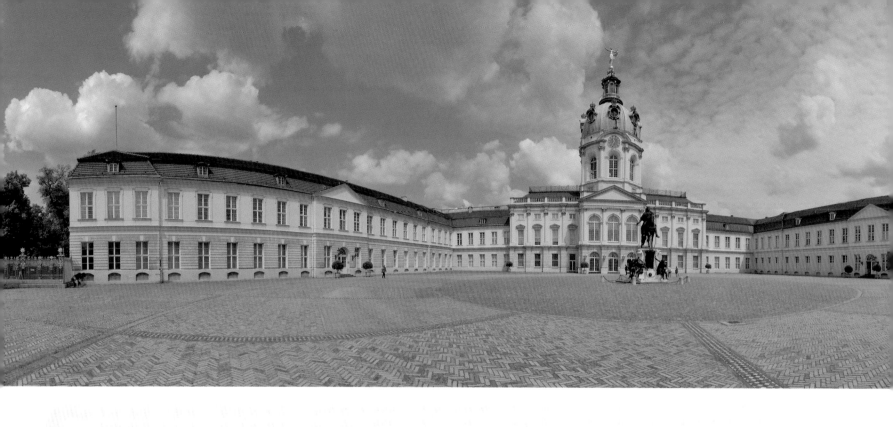

Schloss Charlottenburg – Charlottenburg Palace

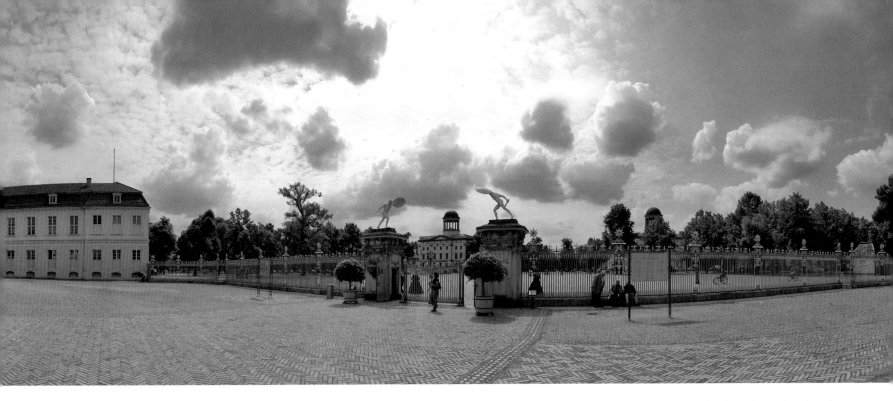

Das als Sommerhaus konzipierte Gebäude wurde im Auftrag von Sophie Charlotte 1695-99 nach Plänen von Johann Arnold Nering errichtet, 1701 von Eosander von Göthe zu einer prachtvollen Anlage umgebaut und 1709-12 um die markante Schlosskuppel und die Orangerie erweitert. Das berühmte Bernsteinzimmer wurde als „Achtes Weltwunder" bezeichnet und 1716 von Friedrich Wilhelm I dem russischen Zaren Peter dem Großen zum Geschenk gemacht.

The palace, designed as a summer residence, was built on the order of Sophie Charlotte in 1695-99, according to plans by Johann Arnold Nering. In 1701, Eosander von Göthe turned it into a magnificent complex, and the striking palace cupola and orangery were added in 1709-12. The famous Amber Room was called the "eighth wonder of the world". In 1716, Friedrich Wilhelm I gave the room to Tsar Peter the Great.

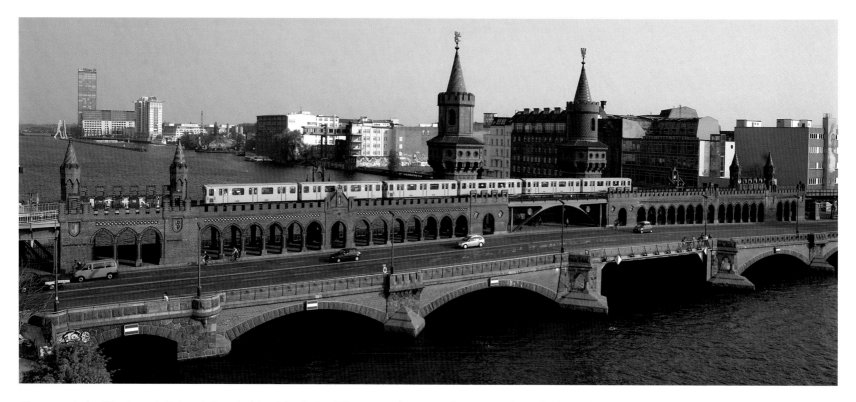

Die neugotische Oberbaumbrücke mit ihren beiden 34 m hohen Türmen wurde 1894-96 nach Plänen von Otto Stahn an Stelle einer alten Holzbrücke errichtet. Die Gleise der U-Bahn wurden 1902 in Betrieb genommen. Nachdem sie 1945 schwer beschädigt wurde, durfte sie ab 1961 nicht mehr passiert werden. Ab 1963 diente sie als Grenzübergang für Fußgänger, wurde nach der Wiedervereinigung saniert und 1995 wieder für den Verkehr freigegeben.

The neo-Gothic Oberbaumbrücke with its two towers of 34 m was built in 1894-96, according to plans by Otto Stahn, to replace an old wooden bridge. The subway tracks on the upper level of the two-storey bridge were first used in 1902. In 1945, the bridge sustained heavy damage and was closed for traffic in 1961. In 1963, it became a border crossing point for pedestrians. After reunification, the bridge was renovated and reopened for traffic in 1995.

City Panoramas 360° – Berlin
1. Auflage

© September 2006, NZ Visitor Publications Ltd.

ISBN 978-3-938446-60-7

Layout und Satz:	Helga Neubauer, Falk Eisleben
Fotos:	Falk Eisleben
Lektorat:	NZ Visitor Publications Ltd.
Druck:	Everbest Printing Co Ltd, China

Zuschriften bitte an:
NZ Visitor Publications Ltd.
Level 27, PWC Tower, 188 Quay Street
Auckland, New Zealand

oder elektronisch an: lektorat@nzpublications.com

City Panoramas 360° – Berlin
1. Edition

© September 2006, NZ Visitor Publications Ltd.

ISBN 978-3-938446-60-7

Layout and typesetting	Helga Neubauer, Falk Eisleben
Photographs	Falk Eisleben
Editing	NZ Visitor Publications Ltd.
Printing	Everbest Printing Co Ltd, China
Translation	languagenetworks, Netherlands

All rights reserved, especially for duplication or dissemination in printed form, or electronic storage in databases, or making available for the public to download, reproduce on a screen or print out by the user. This also relates to pre-releases and excerpts.

The publisher cannot accept responsibility for the contents in this book. We cannot guarantee that this book has not been struck by erronitis. Should this be the case, we would be grateful if you could point out any errors to us.

Please write to:
NZ Visitor Publications Ltd.
Level 27, PWC Tower, 188 Quay Street
Auckland, New Zealand

or via e-mail: editor@nzpublications.com

weitere Bücher aus der Reihe „CITYPANORAMAS 360°"

more books in the "CITYPANORAMAS 360°" series

Hamburg
ISBN 3-938446-43-9

Frankfurt am Main
ISBN 3-938446-41-2

Köln Cologne
ISBN 3-938446-52-2

München Munich
ISBN 3-938446-40-4

Amsterdam
ISBN 3-938446-58-7

Wien Vienna
ISBN 3-938446-42-0